6/24/04

W9-CAG-398

From

your girlfriend

"Lick"

dear friends
are a Treasure
forever....

girlfriends

Girlfriends

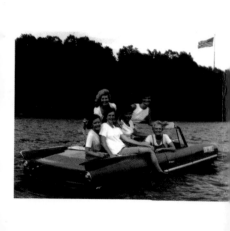

Girlfriends

A Celebration

by Jayne Wexler and Lauren Cowen

RUNNING PRESS

PHILADELPHIA · LONDON

A Running Press® Miniature Edition™

Text © 1999 by Lauren Cowen
Photography © 1999 by Jayne Wexler

All right reserved under the Pan-American and International
Copyright Conventions

Printed in China

*This book may not be reproduced in whole or in part, in any form or
by any means, electronic or mechanical, including photocopying, recording,
or by any information storage and retrieval system now known or hereafter
invented, without written permission from the publisher.*

*The proprietary trade dress, including the size and format, of this
Running Press® Miniature Edition™ is the property of Running
Press. It may not be used or reproduced without the express written
permission of Running Press.*

Library of Congress Cataloging-in-Publication Number 00-131331

ISBN 0-7624-0845-6

This book may be ordered by mail from the publisher.
Please include $1.00 for postage and handling.
But try your bookstore first!

Running Press Book Publishers
125 South Twenty-Second Street
Philadelphia, Pennsylvania 19103-4399

Log onto www.specialfavors.com to order
Running Press Miniature Editions™ with
your own custom-made covers!

In Memory of
Gumaro Hernandez Chasco

To my wonderful group
of friends, incredible women all,
whose understanding and
compassion touch me so deeply.

—JHW

To Jay for risking our friendship
way back then (even if you did have
to listen to Rickie Lee Jones) and
for this lifetime of adventure.

—LJC

I always think of our relationships as a special part of my life. It's like if I could wish one thing for the universe, I would wish for a relationship like this.

barbara armstrong

celia bernheim,
sarah feinberg,
taylor lustig, *and*
mollie reinglass

"We learn from each
other. Like if you get
in a fight with someone
then you don't play with
them for one day. Then
like you get back together
with them, and you
learn that's a nice

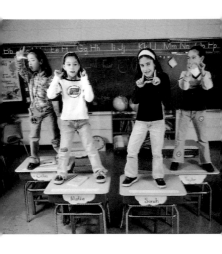

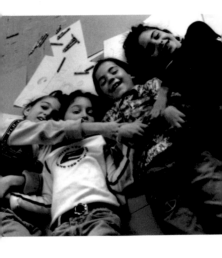

thing to do. Because if you don't, you might not have any friends at all," says Celia.

"We care about each other," reflects Taylor. "We laugh a lot. We don't fight. We help each other."

"She'll call, and my room-mates will put their hands over the phone and say, "It's Katie Holmes!" Then they'll worry that they sound too starstruck. But when they hear me talk about her, they say, 'Well, she must be so easy to talk to. She must be just like you."

meghann birie *and*
katie holmes

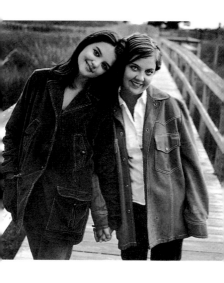

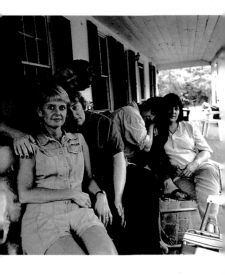

rosemarie brown,
bernadette butcher,
kathy evans,
kathy james, *and*
annmarie mcloughlin

"I don't know how, and I still don't know why," says Bernadette Butcher. "All I know is that it happened. We're totally different people, with totally different interests, and it's so strange to think we came together."

They never really understood each other as friends until they learned that Loretta was going to die.

"I remember having the feeling that here was Loretta making this big tapestry," says Ann. "You could literally feel her pulling everyone together. We were all part of this big picture, and it made us feel so lucky just to be a part of it. I thought, *This is what it means to be alive.*"

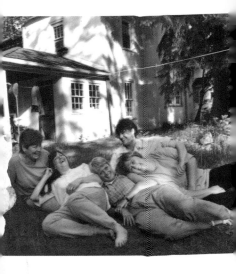

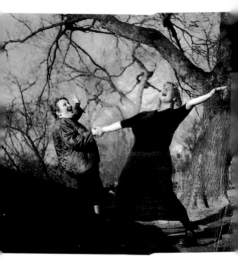

"What is so amazing," says Stepanie, is that I don't have to change to learn from this woman. I didn't quiet myself. I just was myself. And she completely took me as I was and made me blossom."

"Friends my own age give me advice and talk about their problems, but they draw from their well

of experience and tell you
what they think is right for
them. Whereas, when I'm
talking to Stephanie, I am
absolutely transported, as
if I am in her situation, and
I feel the same thing from
her, as if she is in mine. And
yet how can that be?

stephanie st.john
and luba tcheresky

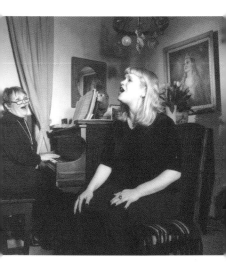

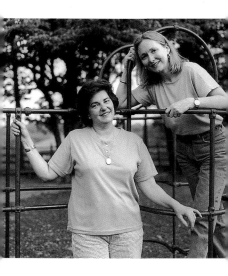

One day when they were twenty-four, Patty Burkhart couldn't hear. First she lost the use of one ear. A year later, she lost the other. Doctors said it was irreversible.

They both learned to sign. Patty learned to read lips. They found various ways to communicate.

"There is something you get in talking with a good friend that you can't get anywhere else," Christine considers. "As a kid, you're trying to piece together who you are. I'm close with my sisters, but they're five and nine years older. You don't find the same understanding as you do with a friend."

patricia burkhart *and*
christine smith

leona rostenberg
and madeleine b. stern

"The delights we have
discovered in detection
were possible only because
we detected and discovered
together. We have been
companions in the search;
we have rejoiced in unison.

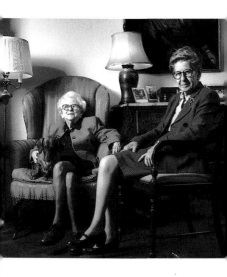

We share our achievements
and our hopes. We still end
each others' sentences. Together
we look to the future——to our
next find, to our next book,
to our next adventure."

"I have this image of us,"
Anne recalls, "literally skipping
arm-in-arm, down the street,
really young and adventurous.
It's the way you are at that age
of wanting to be seen, and yet
being unapproachable."

Says Julie, "It's as if our friend-
ship came of age as we did."

anne christensen *and*
juliann swartz

.

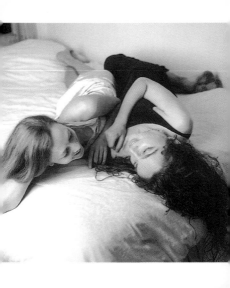

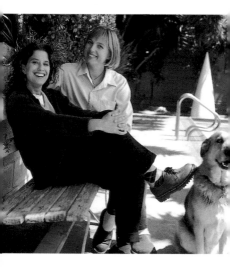

susan feniger *and*
mary sue milliken

"You know, it's almost hard to compare our friendship to any other relationship in our lives because we share this huge bond," considers Susan. "We've worked together for

*Owners and proprietors
of Too Hot Tamales*

so long and we're both
so passionate about our
work that even with
all the people you may
be close with, you just
don't share the same
depth of understand-
ing, of trust."

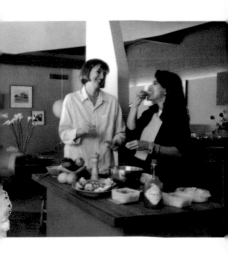

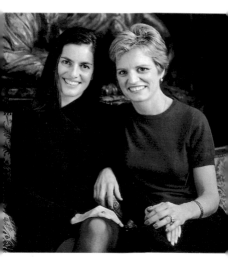

"There's something else that goes back to that theme of being voluntary," Kerry says. "With any relationship you know you can be very close, but there's an expectation that defines it. With Mary, there are no boundaries. There is just a sense of love and support, loving everything that you gain from each other."

"I think of this in an almost religious sense——of responding to why we are put on earth and what God has asked us to do. It's about trying to find good in one another. That is so clear to me in everything Mary has been about."

kerry kennedy cuomo *and*
mary richardson kennedy

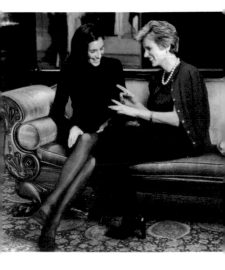

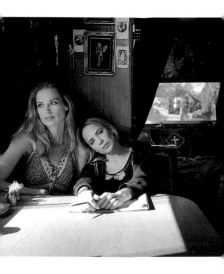

melissa behr
and sherrie rose

"The film is about our friend-
ship," Sherrie says. "When
we met we had followed so
much of the same paths, and I
think that's what drew us to
each other, these tortured pasts.
But then it was like our paths

were so close, you see the
pain and recognize it."

Melissa nods. "We both
helped each other grow
up. Together we could face
things, instead of hiding,
hiding, hiding."

Los Angeles film makers

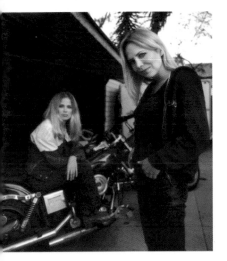

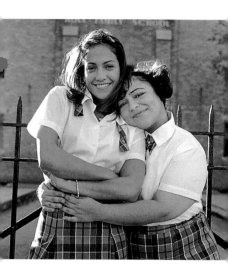

jennifer lopez *and*
arlene rodriguez

"We're like family," she says.
"It's like saying to your
family, 'I can't work with
you anymore.' But it's worse
because it's somebody you
love hanging out with. It's
not like a sister who you
know isn't going anywhere."

"We're not like everybody else," Jennifer says. "On the set, you have all these people and their entourages, everybody acting a certain way, talking a certain way, and then we show up and they're like, 'Where did these two come from?' We're two little girls from the Bronx, exactly the same as we were in second grade."

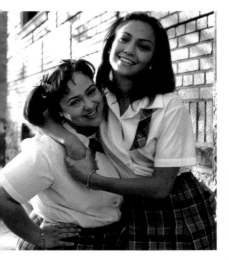

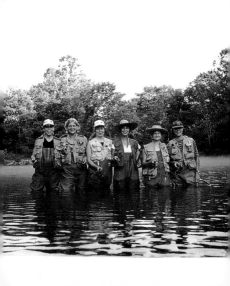

emily eddins *to*
lisa tully dibble,
zola k. gordy,
franny o'gorman,
martha schneickert,
and m.h. van de castle

Dear Sisters,

Ah, the great outdoors, the fresh air, the camaraderie of friends, leaving behind the stress and hectic pace of our daily routine. Once again

it's that time when we
pack our bags, fishing gear,
food, alcohol and whatever
other substances, with the
faith that this year we will
catch enough fish for at
least an appetizer. . . .

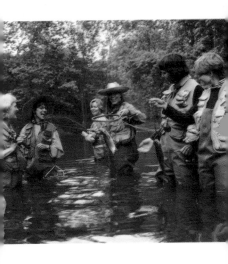

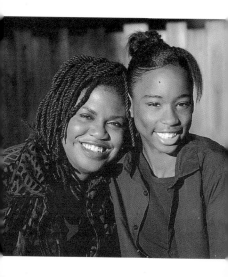

"With Lisa, it's like, she takes me into her world, and shows me things I wouldn't have ever seen. And I think I do the same for her. Isn't that what friendship is really all about?"

lisa collins *and* kimberly hayes taylor

robin arundel,
kristie bretzke,
lisa m. brown,
kristie harrison,
mickey o'kane,
and patti h. soskin

"There is this kind of magic when we're together, this guaranteed good time," says Kristie Harrison. "We have our own language, our own history." At the core of their friendship, she says, is the

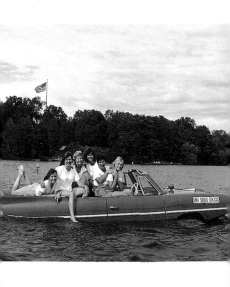

commitment to go everywhere together. "We always travel in a caravan, and if one stops, we all stop; we're only as strong as our weakest link."

"Friendships don't just happen," says Mickey. "It's being together again and again, caring for the details in everyone's lives.

"We don't talk every day," notes Kristin, "but not much happens in our lives that we don't talk about."

"We're competitive on the court and we can say and do whatever and know it's going to be okay. . . . There's something you feel inside when you trust someone—that you can say anything—and that's hard to find," says Keshia.

lakeshia frett
and saudia roundtree

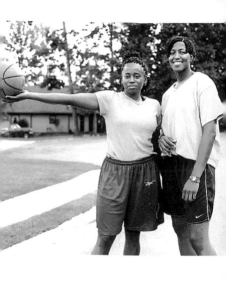

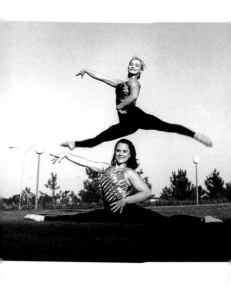

"The only thing that mattered to me was gymnastics. I don't know that I had a single friend. But Karin I feel I've known my whole life," says Kim.

"There's a big difference between competition that is bad and the competition we have," explains Kim. "This is not about jealousy. . . . We're trying to push each other, to make each other better."

kim arnold
and karin lichey

deanna a. morris
and janet l. slagle

"It's sad to say—but true—that some guys would leave you out there," says Janet. "I know she'd never do that. I know that if I go down, she'll be there—she'll pull me out."

"I feel the same way," says Deanna. "I trust her absolutely."

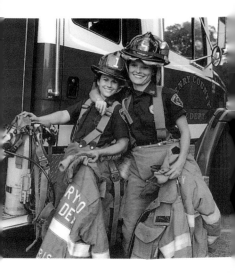

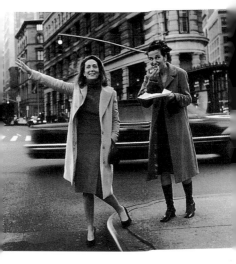

ilene rosenzweig
and cynthia rowley

"You're with this friend who loves you for who you are. That has defined our friendship— always looking at life with this bon vivant spirit, even though we've stood with each other, obviously, through some pretty dark and dramatic times."

Helen met her friend
Ruth in a Japanese camp
where they were prisoners
of war during WWII. "It
became a habit for us to
go daydreaming, sharing
lovely memories of the
past as we hauled wood to
the prison camp kitchen,"
Helen wrote. Ruth has
long since died, and Helen

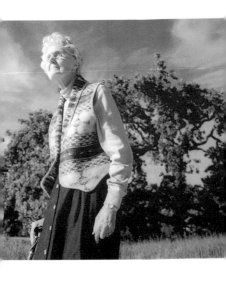

believed the time she spent in the camp had killed part of her as well. But in writing the memoir *Song of Survival*, Helen realized that small accidents of friendship can keep the human spirit alive. She forged new friendships through the making of her book, and then a documentary, a film, and a choral concert.

"Isn't is odd," Helen says, "All the people you meet, you

think, *If I hadn't stepped into that store, or if I hadn't read that book. If I hadn't reached out. . . .* Now I look and see that so many friendships came from that experience, directly or indirectly."

helen colijn *and*
ruth russell roberts

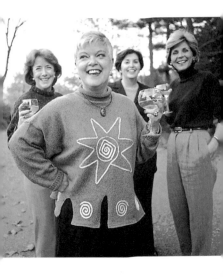

kathleen curry,
patricia hunt dirlam,
holly guild hudson, *and*
cindy mathews

"You need to find support to explore the world, and find out who you need to be rather than who the world tells you to be. It's relationships we build in our journey through the world that helps us get to our destination. ...We never become successes by ourselves."

"I've had girlfriends before," Wini says, "but I don't think I've ever had a friend like her."

Wini turns toward Jo. "I mean to say that you are unusual and unique. You are the friendship that means so much to me."

jo lief *and*
wini scott

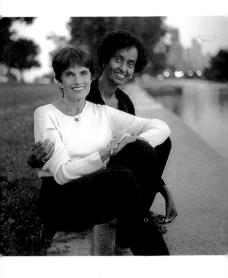

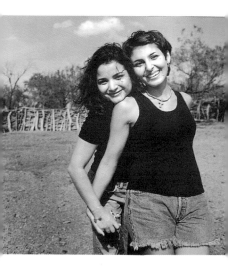

sylvia elizondo *and*
macarena hernández

From nearly the moment
Macarena arrived at Baylor
University, she waged a cam-
paign to get her friend there,
too. "Mac never gave up,"
Sylvia remembers. "Every
time she came home or
called she was always going

on about something—politics
or feminism—and she'd get
me thinking about everything.
She'd be like, 'Sylvia, you need
to leave the valley. How are
you going to know who you
should become?'"

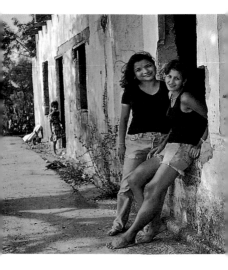

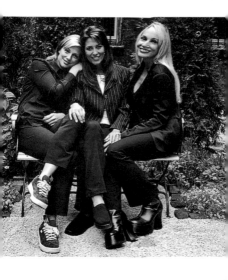

rebecca besser,
debra mcmichael, *and*
eleanor mondale

"There's a certain girl-thing you don't have with spouses. There's something about girls and friendships that is just this amazing mystery," declares Rebecca Besser.

"Girlfriends can't divorce you," says Eleanor Mondale.

"Sometimes, you have friends who are there only in the bad times or the good times. We've been through each other's ups and downs. And though we can't always be together, the closeness is there," says Debra. "We all know we're never alone."

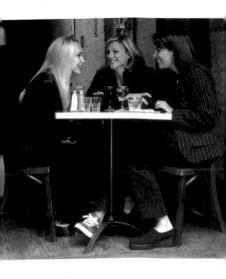

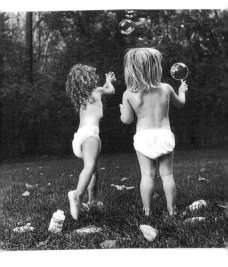

Lauren Eiden and Gabrielle Ilana Levine share a favorite pastime—chasing bubbles. When asked why they are friends, Gabrielle and Lauren only offer a shrug and say, "Because I like her" and "We have fun."

lauren eiden *and*
gabrielle ilana levine

rebecca guberman
and jennifer jako

"Before I met Jako, I was so isolated," Rebecca remembers. "I felt so different, as if everyone looked at me and said, 'Oh, that's the girl who has HIV.' When I met her, it was like suddenly having my eyes opened—this amazing feeling of empowerment."

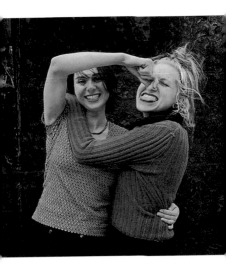

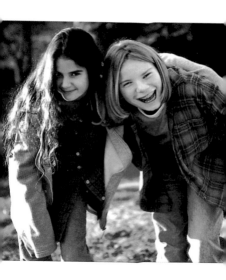

"Before, I'd be walking to school, saying like, 'Please don't let them tease me,'" remembers Kate. But with Sammerah at her side, "I felt much safer. . . like someone was watching over me."

sammerah qawasmy
and kate fluehr trainor

bai ling *and*
mao tian yuan

At fourteen, Bai Ling was recruited into the People's Liberation Army. She can still hear her dear friend Mao crying the day they learned Bai was leaving. "When I got the news, she rode over on her bicycle. She was yelling at me from downstairs—I lived on the third floor. She tossed her bicycle, ran to me, and hugged me very hard. She was crying very, very loud. I felt like she was crying for me."

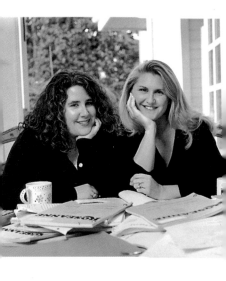

eileen **heisler**
and deann **heline**

"It's not that we end each other's sentences," Eileen says, "it's that we never have to start them."

Sit-com writers

ellen allen,
karen neal-mustard,
nicole allen,
and haley mustard

"We were both coming from our work lives, making the transition to motherhood," says Ellen. "And there was no pretension, no baggage." "Our husbands connect, our children connect—it's just this very easy thing," says Karen.

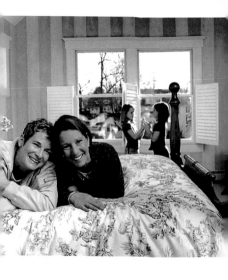

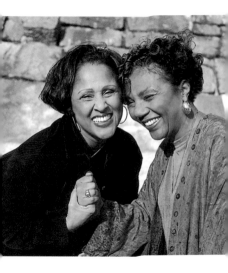

"There are things I would do for Barbara that I wouldn't do for anybody else," says Darlene. "I would lay down my life for Barbara, like I would for my kids or my mother. Now these other friends, I may love them, but I ain't gonna lay down my life for them, you know what I'm saying?"

"No matter where we are, or how long it's been since we last

talked, we don't have to go through the preliminaries," Barbara notes. "We just jump in and know that this friend will stop and listen and weigh in, and tell you the truth. That is one of the loveliest parts of our relationship. We can talk about everything."

barbara johnson-armstrong
and darlene love

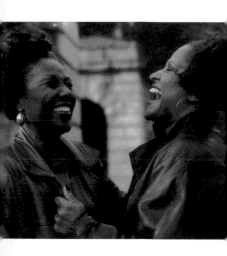

This book has been bound
using handcraft
methods, and Smyth-sewn
to ensure durability.

The interior was designed
by Maria Taffera Lewis
and Frances J. Soo Ping Chow.

The text was edited
by Molly Jay.

The text was set in
Bembo.

girl

friends

girlfriends

girlfriends

girlfrien

girlfriends